A GUIDE TO ZUNI FETISHES

FETISHES

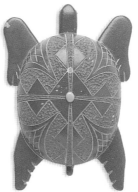

AND CARVINGS

WESTERN
NATIONAL PARKS
ASSOCIATION

TUCSON, ARIZONA

Published by Western National Parks Association

The net proceeds from WNPA publications
support educational and research programs
in the national parks.

Receive a free Western National Parks Association
catalog, featuring hundreds of publications. Email:
info@wnpa.org or visit www.wnpa.org

Library of Congress Cataloging-in-Publication Data
Lamb, Susan, 1951–
 A guide to Zuni fetishes and carvings/
 [written by Susan Lamb].
 p. cm.
 ISBN 1–58369–028–X
 Zuni sculpture. 2. Fetishes (ceremonial objects)—
 New Mexico. I. Title.
E99.Z9 L37 2002
730'.89'979—dc21 2002071364

Written by Susan Lamb
Edited by Abby Mogollón
Designed by Mo Martin
Photography by Thomas Veneklasen
Cover carving by Darrin Boone
Title page carving by Darren Shebola
Printing by C & C Offset
Printed in China

With gratitude to the gracious, informative,
and hospitable staff of the A:shiwi A:wan
Museum and Heritage Center, especially
Garrett Banteah and Lena Tsethlikai.
Also thanks to the Sonora Trading Company.

CONTENTS

INTRODUCTION

For at least a thousand years, the **Zuni** people (**A:shiwi**) have venerated **fetishes**, or objects in the shape of animals they believe are imbued with the spirits of powerful beings that protect, heal, and help their owners. Today, dozens of families carve animal figures derived from the original fetishes to sell to visitors and collectors all over the world through museum shops, mail order, and the Internet. These tiny allies continue to benefit the Zuni by supplementing the income available in this beautiful but remote nation.

Zuni tradition maintains that fetishes originated in the "Time of the Beginning" when we humans climbed up from a shadowy netherworld into the sunshine of this one. Yet our new home was swampy and we floundered, preyed upon by ravenous beasts. The Warrior Twins, offspring of the sun, hardened the mud but still the beasts could catch us. And so with a bow (the rainbow) and arrows (lightning), the Twins struck those who pursued us, turning them to stone. Some of these ancient predators can be recognized in rock formations in the landscape, although they are somewhat worn down by wind and water. Many that were shriveled into miniature versions of their former selves are occasionally discovered lying on the ground. Even though these animals have been petrified, their spirits are still alive inside.

In the old days, Zuni hunters and holy men might collect a stone, bone, or piece of wood that resembled an animal and enhance that resemblance with paint

Boldface words are in the glossary

or carving. They might add inlaid eyes or wrap it with feathers and an arrowhead to represent the lightning with which the Warrior Twins transformed the original beast long ago. Some fetishes might receive a **heartline**, in accord with the Zuni belief that animals charm and capture their prey with breath from their hearts and lungs.

Animals in today's world do not have the same great powers as the **archetypes** represented by these fetishes. They may be hunted, killed, and eaten within certain ceremonial guidelines. However, animals of today do still have abilities such as gnawing, flying, and singing, which their ancestors used to help heroes out of their difficulties in Zuni legends. In addition, present-day animals are believed to be closer to their mythic origins than people are and more effective in communicating with the powers of the natural world.

A sacred fetish would never be sold but it might be given away by a friend or family member, especially to a child learning about Zuni religion. Some fetishes are carried in a pocket or

Tiffany Babebaye
[PICASSO MARBLE LIZARD]

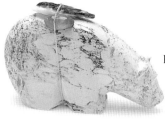

Priscilla Lasiloo
[SERPENTINE BEAR]

pouch, while others are kept in ceramic pots and lovingly tended by their human families.

For centuries, the Zuni have also carved little animal-shaped talismans for sale or trade to people not of their world view. Generally, they prefer that such non-sacred animal figurines be called simply "carvings" rather than "fetishes." In the early days, these were usually carved of local materials to represent the wild creatures of the Zuni homeland. After Spanish settlers introduced livestock, the Zuni began to carve domestic animals as well. Navajo herders in the area commonly kept Zuni carvings of sheep, horses, or cows.

During a revival of interest in Native American cultures in the 1960s, necklaces of miniature birds and animals strung with beads, turquoise, coral, or shell became popular. As the wider world has become familiar through books, television, movies, and travel, exotic creatures both real and imaginary have become popular subjects. With modern electric tools, artists can now carve very realistic animals and detailed Corn Maidens. Artists experiment with imported shells and semiprecious stones as well as with horn, bone, wood, or pottery.

Collectors prize genuine Zuni carvings as a form of contemporary traditional art and the families who

make them hold the status of fine artists. Carvers price their work based upon the number of hours it took to create, the beauty or rarity of the stone, and how successful the finished piece is. A carving that is especially large or detailed or made of an unusual stone is likely to cost more than a smaller or simpler one of a common material. Carvings that have been chipped, scratched, or repaired have less commercial value, although they may have lost none of their personality.

Unfortunately, disreputable stores sell cheap imitations mass-produced by counterfeiters of other cultures and countries, to the detriment of Zuni livelihoods. For this reason, many Zuni carvers now sign their work despite their view that every carving is a collaborative effort by the whole community, past and present.

Although the Zuni carvings that are sold are not true fetishes because they have not been blessed, many of them seem to have a life of their own. These little creatures appeal to us in a way that is difficult to define. We find them charming in every sense of the word, evocative of the natural world they represent.

Whether or not we understand the worldview of Zuni artists, their carvings have the ability to create a connection between ourselves and another being. If one of these carvings delights you, reflect on its living animal counterpart. Take a moment to consider the Zuni conviction that for our lives to be truly blessed, we must maintain a good relationship with the creatures of the natural world.

BEASTS AND PREDATORS OF THE SIX DIRECTIONS

With outsiders, Zunis use the cardinal directions of north, west, south, and east. However, the traditional Zuni compass is based upon the four "solstice points" on the horizon, where sunrise and sunset occur on the shortest and longest days of the year. Zuni tradition maintains that long ago, a gigantic water strider stretched its four legs out toward each of these points, forming an "x" with **Idiwan'a**—the Middle Place where the Zuni now live—under its heart. Vital blessings come from each of the directions, such as the Zuni River flowing into the village from the northeast, the summer rains from the southeast, and the winter snow from the northwest.

In Zuni tradition, all creatures—including us—were transformed as we arrived in this world. The Warrior Twins transformed those who had healing powers into the Beasts of the Six Directions, corresponding to the four directions of the Zuni compass and to the **zenith** and the **nadir**. Each of these Beasts can intercede for us with the powers that originate in its direction to bring us prosperity and health. For example, they may influence rain-bearing clouds to visit parched farms, or heal an illness or injury that is physical, emotional, or spiritual.

Each direction also has a predator, or "**Prey Beast**." Animals good at stalking, chasing, digging out their prey, or "ganging up" on it are asked to help heads

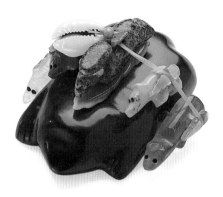

Jayne Quam
[BLACK MARBLE SIX DIRECTIONS BADGER]

of households feed their families. Four of these preda-
tors are the same as the guardians of the Six Directions,
but in the west the coyote replaces the bear and in the
south the bobcat takes the place of the badger.

Carvings of other animals are now common, also.
Although they are not imbued with great powers like
those of the Beasts of the Six Directions, they create
a metaphorical connection between their human
caretakers and their own kind.

The Zuni associate specific colors with each direction.
Some collectors like to obtain **directional sets** of six
Zuni carvings: yellow for north, blue for west, red for
south, white for east, multicolored for the sky, and
black for the netherworld.

Hokdidasha — MOUNTAIN LION

*NORTH — DIRECTION OF THE SWEPT
OR BARREN PLACE*

The mountain lion is an elusive, golden creature associated with the yellow north. There are several names in English for this animal including cougar, panther, puma, and painter. Elder Brothers who dominate all other beasts, lions are the first to be addressed in appeals to the six directions, which are then listed counter-clockwise.

Lions offer protection from any threat to wellbeing that originates in the north. Winter comes from this direction. It is a season for hunting rather than for gathering plants or cultivating corn.

With its keen eyesight, strength, and agility, the mountain lion can successfully hunt virtually any other animal and is considered the most potent of the predators, or "Prey Beasts." It is especially important in hunting deer. Because of its courage, the mountain lion is a powerful ally in war.

Mountain lions are among the oldest carvings made. Usually, they have a long tail lying along their backs and small, round ears.

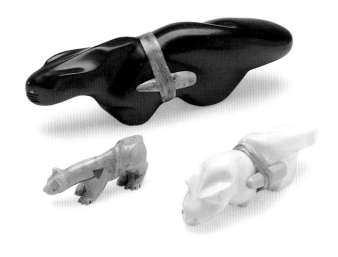

Dion Terrazas [JET MOUNTAIN LION]

Herbert Halate [SERPENTINE MOUNTAIN LION]

Andres Quandelacy [TURQUOISE MOUNTAIN LION]

Anshe, Suski BEAR, COYOTE

***WEST — DIRECTION OF THE HOME
OF THE WATERS AND OF EVENING***

The bear is a shambling creature associated with
the blue west whose Zuni nickname is Clumsy Foot.
Once brown grizzly bears roamed the Zuni home-
land, but now there are only small black bears. Kill-
ing a bear is very serious and requires initiation
into an exclusive society.

When they rear up on hind legs, bears can look almost
human. Zuni hunters know that the skeleton and mus-
culature of a bear is more like a person's than one might
expect. Bears have personalities like people do and can
be playful or grumpy. Traditional stories tell
of bears that have broken their code of silence in
emergencies to speak to human beings.

Yet as animals, bears remain forever mysterious. They
are considered great healers, perhaps because of their
robust health and their physical similarity to us. They
are eloquent voices for compassion.

The coyote is the designated predator animal of the
west. Bears and coyotes are both **omnivores** but coyotes
are very creative, sometimes tricky hunters. They often
hunt in tandem with other coyotes or with reluctant
partners like badgers, which can startle prey into run-
ning toward the coyote's waiting jaws.

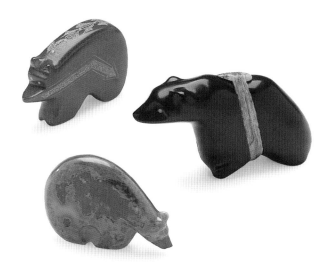

Patrick Wallace [PIPESTONE BEAR]

Priscilla Lasiloo [BLACK MARBLE BEAR WITH OFFERING]

Prudencia Quam [PICASSO MARBLE BEAR]

Donashi, Debi~ BADGER, BOBCAT

**SOUTH — DIRECTION OF THE BEAUTIFUL
RED AND THE ZUNI SALT LAKE**

The badger is a symbolically significant creature associated with the red south. Badgers are fierce and determined, important qualities in a challenging environment. They dig fast and powerfully after burrowing rodents or in retreat from an enemy, creating holes, tunnels and barriers that we humans—who also build earthen structures—can appreciate.

Badgers travel surprising distances up into the mountains in summer and down to lower, warmer elevations in winter. They are associated with fire—among other reasons because dried roots are traditionally used to start fires and because erupting lava also starts fire—and with the sun, which is the fire in the sky. A major clan at Zuni is the Badger Clan, which has responsibilities at the winter solstice when the sun is encouraged to return from its sojourn in the south. Badgers, with their understanding of roots and other parts of medicinal plants, are wise in the ways of curing illness and injury.

The bobcat is the predator traditionally associated with the south. Also called wildcat or lynx cat, bobcats are nimble, opportunistic survivors that pursue small prey ranging from cottontails to snakes to kangaroo rats in a variety of habitats including stands of cottonwood, thickets of arrowweed, open grassland, and rocky outcroppings.

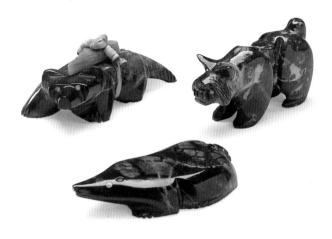

Bernard Laiwekate [PICASSO MARBLE BADGER]

Rosella Lunasee [RASPBERRY SERPENTINE BOBCAT]

Ephran Chavez [PICASSO MARBLE BADGER]

Yuna:wik'o — WOLF

EAST — DIRECTION OF DAWN

The wolf represents the white east and is also the predator associated with that direction. The wolf has a hanging tail, alert ears, and a slanting face, although various carvers create very different portraits of them.

Wolves are family animals. They usually mate for life and raise their families in carefully chosen dens that make the most of spring sunshine or good vantage-points, not unlike human homes. Most of their offspring remain together in kinship groups and they share their kills with one another down to the last bone, albeit with some degree of tussling.

Wolves are lean, long-legged travelers of territories that can have a radius of twenty to sixty miles. As pets of the Warrior Twins, they are good allies in war as are their cousins, the domestic dogs that have been part of Zuni households since time immemorial. In stories, wolves sometimes serve as watchdogs for humans who have done them a favor.

Wolves are swift runners that can chase their prey to exhaustion. They hunt in coordinated pairs or packs, encircling an animal and then going in for the kill. Wolves are thought to prefer elk as their prey.

Because the wolf population diminished so drastically over the past century or so, the fox is sometimes substituted for the wolf as the animal of the east.

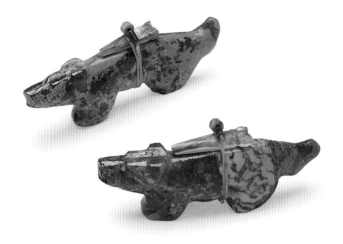

Juana Homer
[SERPENTINE WOLF] & [TURQUOISE WOLF]

K'yak'yali — EAGLE

ZENITH — DIRECTION OF THE HOME OF THE HIGH

The eagle is associated with the sky and the regions even higher, into which this upward-spiraling raptor seems to disappear. It wheels freely about in the lofty realm of the zenith, its feathers supporting it between earth and the heavens. As a familiar of clouds and wind, lightning and sun, the eagle and its feathers are likely intermediaries between human beings and the powers in the sky, especially the sun.

Shafts of sunlight look white and they bleach the color from whatever they strike, such as motes of dust or a wall across from a window in a darkened room. Depending upon the weather, the sky can glow with any color imaginable and during afternoon storms it is brightened with spectacular rainbows of every color. Carvers often choose white, iridescent, or multi-colored stones or shells to shape into eagles.

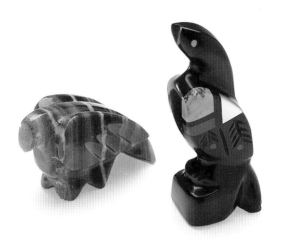

Frankie Eustace [PICASSO EAGLE]

Steven Natachu [JET EAGLE]

K'yaluts'i ~ MOLE

NADIR — DIRECTION OF THE HOME OF THE LOW

The mole is the Beast of the nether regions, the world below ground. In that darkness, the dominant color is black.

At first it might seem strange that the mole is included in the Zuni worldview, since moles are not native to the Zuni homelands in New Mexico and Arizona. They do resemble shrews, which are found in the area and are closely related, insect-eating animals, but shrews do not burrow underground as moles do. Native pocket gophers dig holes and tunnels, but they are not much like moles in other ways.

Like the other Beasts of the Six Directions, moles derive their significance from ancient stories. Tradition says that moles aided humans in their ascent from the previous world and helped guide the Zuni people along their winding route to Idiwan'a.

Moles are guardians of gardens. Like badgers, they are familiar with the soil and the plants that grow in it, and they hunt the grubs that damage crops. They serve as intercessors between humans and the powers that originate belowground.

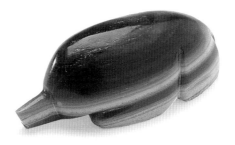

Terrance Tsethlikia [MALACHITE MOLE]

GAME ANIMALS

Zuni hunters may carry a fetish of a predator or its prey along with them in order to focus prayers for a successful hunt upon it, to symbolically thank it when the quarry has been slain, and to acknowledge that humans are dependent upon its kind. Zuni families may also care for a fetish in their homes to encourage the future abundance of its kind on earth.

As with all religious imagery, Zuni fetishes are not limited to one simple interpretation. While a primary purpose of game fetishes is to foster prosperity and success in the hunt for a living, knowing the characteristics of each animal also helps to strengthen the bond between people and nature. Tending these little carvings with reverence and respect is one way that Zuni people fulfill their role in keeping balance in the universe.

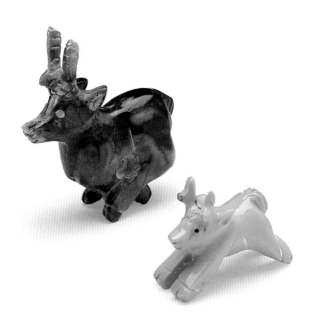

Fabian Tsethlikai
[PICASSO MARBLE DEER] & [TURQUOISE DEER]

Okshik 'o RABBIT

The rabbit has always been the most abundant animal hunted by the Zuni for food. Rabbits, which reproduce up to four times a year, are very easy to hunt. A child can take one with a snare or a simple throwing-stick. They neither hibernate nor migrate out of range of the village during a snowy winter. Their fur is warm and soft and was once an important material in cloaks and blankets. The Zuni also hunt rabbits to prevent them from devastating corn and other crops. Rabbits do not seek protection in groups but live as individuals. Ceremonial hunts reflect the central role of rabbits in the survival of the Zuni over centuries.

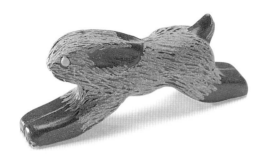

Darren Shebola [PIPESTONE RABBIT]

Si:wolo—BISON

Bison (also called American buffalo) are not native to the Zuni homeland. Once very numerous, these enormous animals graze the Great Plains east of the Rocky Mountains. In the old days, other tribes and pueblos hunted bison to trade to the Zuni, who prized warm buffalo robes and made the tough, strong hides into clothing, moccasins, shields, and helmets. Hunting these massive, horned animals was very dangerous. But while killing them required a warrior's courage, exchanging their meat and hides was the basis for peaceful interaction between the different people of the region.

Bison are associated with winter, especially snow. They are strong and live in large, synchronized, mostly harmonious groups. Although no longer traded to the Zuni, bison continue to represent strength, warmth, abundance, and community survival in a harsh environment.

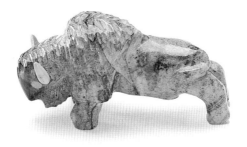

Robert Kanteena [PICASSO MARBLE BISON]

Na ala, Na lih—DEER, ELK

Members of the deer family—elk, whitetail, and mule deer—are a common subject in ancient **petroglyphs**, on pottery, and in ceremonial dances. Although they are important as a source of food and materials, they were seldom carved in any detail until recently because their long legs and antlers were difficult to achieve with the old tools.

The Zuni hunt deer and elk mostly in autumn and winter, when farming is over for the year and the animals do not have young. Traditional hunters sing to attract, disarm, and thank the animals. Songs for deer combine with prayers for rain; calling in deer is like singing in rain clouds. Fetishes of these animals focus invocations for abundance in the natural world.

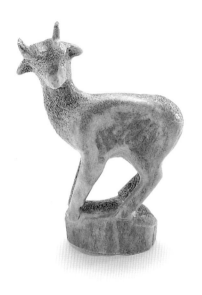

Max Laate [ANTLER DEER]

Halik'u — BIGHORN SHEEP

There are many ancient petroglyphs of bighorn sheep around Zuni. Bighorns were an important source of food in ancient times, and the rams are still associated with male fertility. Also, since they are preyed upon by lions, wolves, and eagles, a fetish of a bighorn might not only prove helpful in hunting one but also in attracting these particular Beasts of the Six Directions when their healing power is needed.

Pronghorn grow horns rather than antlers and are more closely related to sheep than to deer. They often bear twins and form herds in winter. Alert and curious, they can be attracted by a person lying in the grass waving a strip of cloth. Pronghorn can reach speeds of more than thirty miles an hour but once exhausted, they are helpless.

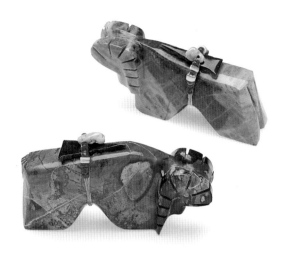

Toni Laiwekate

[PICASSO MARBLE RAMS]

Wo'ts'ana — BIRDS

Light and quick, birds travel free and far in a vertical, rather than a horizontal world. Each is like an embodied breath carrying messages back and forth between the powers of nature, human beings, and their fellow creatures.

Birds sing to announce spring and some of them depart in autumn. At Zuni, the behavior of perhaps two hundred birds is correlated with other important weather events such as impending snowfall or drought. Every bird, from wild turkeys to hummingbirds, has a role in the workings of the universe.

Along with the eagle and its relatives the redtailed hawk and falcon, there are several other birds often carved by Zuni artists. These birds and a few of their basic associations include the owl and its familiarity with night and darkness, the raven and its interference in peoples' lives, the turkey's connection with the earth, hummingbirds and their affinity with rain, the macaw's link to the sun and to the mythic origins of the Zuni in Mesoamerica, and the duck's affinity with bodies of water, especially Zuni Salt Lake.

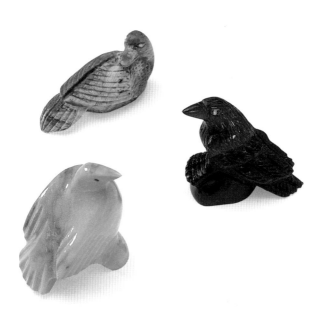

Jethro Mahkee [PICASSO MARBLE DUCK]

Cellester Laate [BLACK MARBLE RAVEN]

Calvert Bowannie [TURQUOISE BIRD]

Edo:wa, Dakkya—TURTLE, FROG

Frogs and turtles are associated with water and fertility. Together with other water creatures such as dragonflies, tadpoles, fish, and toads, they have been painted on pottery and chipped into boulders near springs, lakes, and streams for centuries. Today, modern tools enable carvers to find their shapes in small stones.

In Zuni stories about the Time of the Beginning, neither people nor animals looked or behaved quite as they do now. All creatures, even those who became insects and flowers, spoke to each other then. Humans were **moss people**, slimy like frogs and with webbed hands and feet. The Warrior Twins cut through our webbing, distancing us from our origins.

Frogs, turtles, toads, dragonflies, and fish never severed their connection with water. During a flood not long after the emergence, these water animals helped us and other creatures to survive. The turtle even carried us on his back. Humans continue to ask these beings to intercede and assure enough rainfall and springs of water.

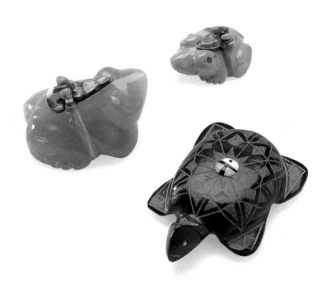

Leland Boone [ORANGE ALABASTER FROG]

Dilbert Gasper [BLACK MARBLE TURTLE]

Raymond Tsethlikai [TURQUOISE FROG]

Misho, Chitdola— LIZARD, SNAKE

Lizards—with their tails, tiny hands, hairless bodies, and watchful eyes—look much like humans did at the Time of the Beginning, before the Warrior Twins cut off our tails. But just as frogs kept their "raw" appearance, lizards stayed faithful to their original form. They maintain a closer relationship to nature than people do.

On the other hand, the Twins did humanity a favor. As moss people, we lived in mindless chaos until the Twins reshaped us and hardened the surface of the earth with the sun's heat. Lizards remind us of our collective journey as human beings, of our progress and also of what we have lost.

With their swiftness and undulating linear shape, snakes resemble the lightning that accompanies rain. They travel in and out of the ground and are familiar with the lower world, including seeds and roots. These connections with both death and life make snakes powerful healers.

The plumed water serpent is a mythic figure known throughout Mesoamerica and the Southwest. Called Kolowisi by the Zuni, it is a guardian of the springs and ponds in which it dwells.

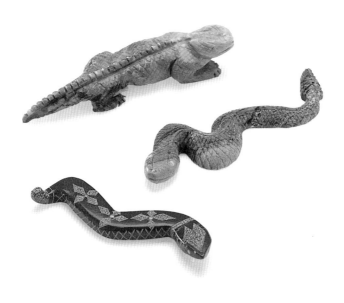

Sedrick Banteah [PICASSO MARBLE LIZARD]

Jethro Mahkee [SERPENTINE SNAKE]

Patrick Wallace [PIPESTONE SNAKE]

Dow e:washdok'i CORN MAIDENS

There are many stories about the Corn Maidens. They encouraged the first corn to grow by pulling on it, leaving marks on the plants where their fingers gripped the stalks. As they and their consorts embraced the plants by the changing light from a bonfire, the ears of corn acquired their different colors.

The Corn Maidens are daughters of the sun and sisters of a raffish fellow who inappropriately desires them. When they flee him, winter ensues. When the Zuni people neglect them, there is drought and the corn does not grow or ripen. They must be begged and coaxed to return and to bring the health and fertility that they exhale in their very breath. They are associated with the seasons and with the flesh of the corn itself. There are eight Corn Maidens: six associated with the differently colored corn of the six directions, one for sweet corn, and one for squash.

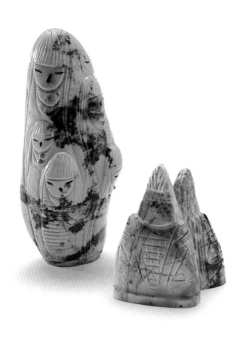

Sandra Quandelacy [TURQUOISE CORN MAIDEN]

Ben Bacy [PICASSO MARBLE CORN MAIDEN]

LIVESTOCK

Horses, cattle, sheep, and goats were among the first animals carved by Zunis for outsiders. They have been made mostly for Navajo people, whose livelihood is centered on livestock. The Navajo are justly famous for their adaptability and for their willingness to integrate ideas from other cultures into their own worldview. In adopting Zuni carvings of domestic animals, they demonstrate their readiness to try whatever may be necessary to ensure the health, fertility, and security of their livestock.

Before Spanish colonists arrived in the mid-1600s, the only animals domesticated by Zuni people were dogs and turkeys. Neither was kept primarily for meat, but rather because trusty dogs kept watch over children, villages, and fields and because turkeys provided feathers and bones for whistles, awls, and other implements. With the advent of domestic livestock, there was suddenly a reliable meat supply, plentiful hides, and beasts of burden—all objects of gratitude and concern.

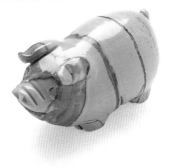

Gerald Burns [ALABASTER HORSE]

Stanton Hannaweeke [DOLOMITE PIG]

CREATURES FROM FAR AWAY

The people who live in Idiwan'a are steeped in their own traditions but they are also very aware of the wider world. Through magazines and movies, television and travel, they are acquainted with the creatures of faraway continents and distant seas as well as with the beasts of long ago, such as dinosaurs. Zuni carvers understand that the creatures of every time and place have important qualities and great significance in their own contexts.

Collectors have also encouraged Zuni artists to carve animals not native to the area. Some visitors simply love penguins, for example, or are concerned about the well-being of whales. Their purchases lead to the availability of more kinds of animal carvings and an increased opportunity for cross-cultural communication.

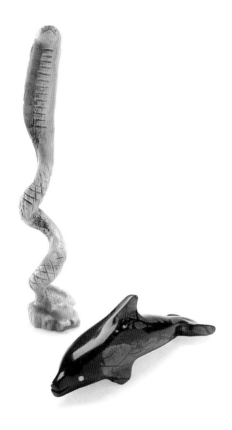

Joseph Deyeu [ANTLER COBRA]

Lorene Eustzee [BLACK MARBLE DOLPHIN]

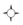

IMAGINARY BEINGS

As Zuni carvers have expanded their range of subjects, they have given freer rein to their imaginations. Today, one can find marvelous beings from dragons to modern superheroes that have been carved with great skill and spirit. These carvings tend to be very detailed and clearly recognizable. Rather than referring to the ancient teachings handed down from Zuni ancestors, they tap into a set of symbols that is easily recognized in today's mass culture. Although there are ways that modern culture conflicts with traditional societies around the world, its imagery is known on every continent. Mass-culture symbols are a common ground between people of different backgrounds.

Calvin Weeka [PICASSO MARBLE]

GLOSSARY

ARCHETYPE: the original ideal from which all subsequent forms are derived.

A:SHIWI: the name of the Zuni people in their own language.

DIRECTIONAL SET: a collection with one of each beast and/or color from each direction.

FETISH: among the Zuni, an animal-shaped object which has been blessed and which contains the spirit of a powerful being that can protect, heal, and/or help its owner.

HEARTLINE: a line indicating the path of the breath and power of the spirit.

IDIWAN'A: the Middle Place where the A:shiwi now live.

MOSS PEOPLE: mythical, early form of human beings.

NADIR: the downward direction.

OMNIVORE: consumes plants as well as meat.

PETROGLYPH: an image carved or chiseled into stone.

PREY BEAST: an archetypal predator.

ZENITH: the upward direction.

ZUNI: the A:shiwi's modern tribal name. It is derived from siáni, their name in the Keresan language of several neighboring Pueblos.

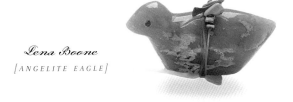

Lena Boone
[ANGELITE EAGLE]